Leisure Arts 43

Oil Painting with a Knife

Brian Bennett

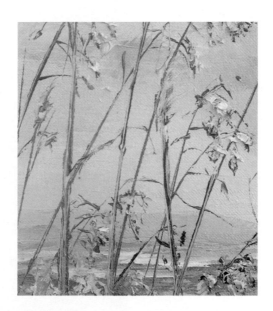

SEARCH PRESS

Introduction

Why paint with a knife? Most painters use brushes and have done so throughout the history of art. A knife can be a clumsy and insensitive tool in inexpert hands and it is certainly no magic instrument by which an indifferent painter can be transformed into a great one. When learning, though, it can help to bring about a broader and more simplified approach which is very useful.

This was certainly what led me to take up the knife. I needed to overcome the habit of fiddling about on unnecessary detail with small, thinly loaded brushes, and a knife seemed to be the answer. I felt sure that no matter how carefully I used a knife, only fairly broad effects would be possible. Also, since I was rather slow to clean my brushes, and was always having to throw them away when one end got as hard as the other, I thought I might save some money that way. It did indeed stop me from niggling quite so much, but as an economic measure it proved a failure: my bill for paint went up, as a knife tended to use a lot more of it. However, I still think that the improvement I made in style more than made up for the extra expense.

In this book, I hope to inspire you to paint in a bolder way, as I found I did, and with greater freedom of expression.

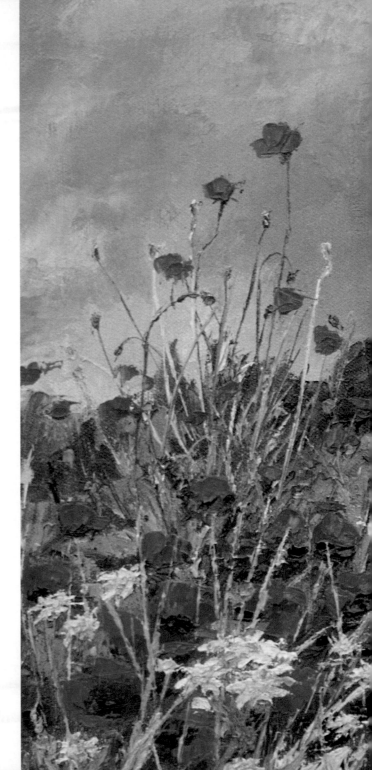

Edlesborough Church with summer flowers

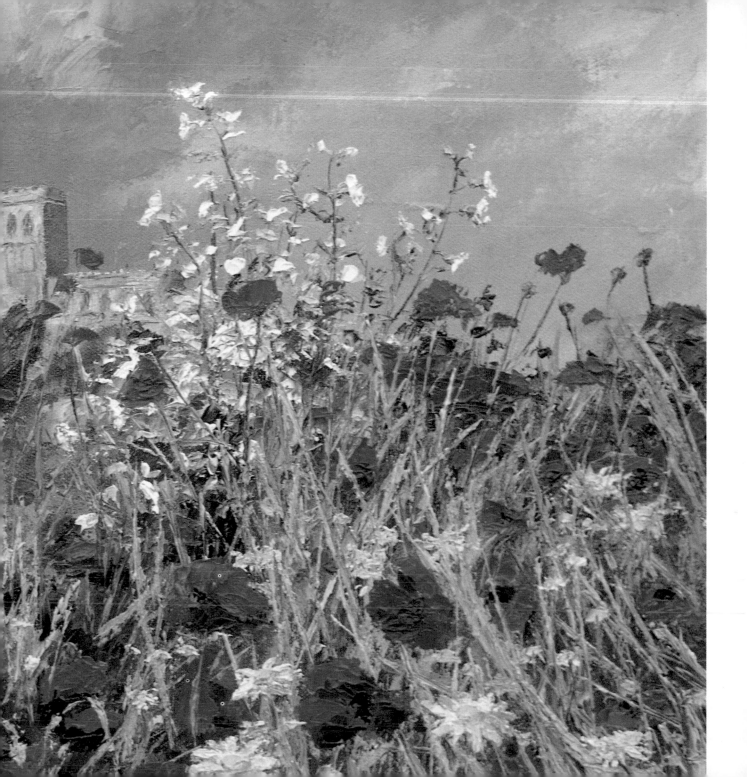

Choosing and using a knife

Since I started painting with a knife, I have come to realize that there are knives and knives, some rather more decorative than really useful. They are frequently – and wrongly – called palette knives, and I have even heard people accuse me of painting with a palette, which conjures up an interesting mental image! A painting knife is always cranked, of course, and is generally more flexible than the true palette knife, but it should not be too much so. A blade that is so thin that it more or less bends in the wind is not going to be of any greater help than a rigid and unyielding palette knife. So, the first point to remember is to take care when choosing.

Selecting a knife

Obviously, a knife must suit your own personal taste and style, but at the same time it is worth while bearing in mind one or two general principles when faced with the wide variety of shapes and sizes to be found in most catalogues and shops. If a blade is too small, then it can only be used when you are going to put the paint on in small individual blobs. This technique generally produces a fussy and unpleasing effect and is not to be encouraged! Indeed, it is this sort of over-textured way of painting that gets knives a bad name.

At the other extreme, those long, slender, elegant blades are worse than useless. The tips are so far out of control that you will probably scrape as much paint off with them as you apply. Moreover, the flimsy end is extremely prone to being bent, and when this happens ugly scratches appear all over the work, causing a lot of unnecessary frustration and despondency. Once bent, the blade can never be straightened satisfactorily. So avoid these, no matter how attractive they look.

In other words, anything under 5cm (2in) can be disregarded and anything much over that has to be shortened. The tips, too, generally need adjusting. Either they tend to be too rounded or they have such sharp corners that they can cause accidents either on, or, even worse, actually *to* the canvas.

My first consideration, however, is to make sure that the shank is strong enough. A certain amount of pressure is bound to be used when working, and a satisfactory knife must be able to withstand such pressure. Some otherwise serviceable knives are joined to their handles by what seems little more

than heavy wire. These are clearly of no practical use. When I have found something tough enough I nearly always have to set about adapting the blade to my own requirements, for I have discovered nothing from any manufacturer that entirely suits me.

Adapting a knife

To adapt a knife, firstly I file carefully across the end, not straight across, but at an oblique angle, snapping off the unwanted piece and smoothing away any raggedness with the file. The truncated end thus produced can serve, should it ever be needed, in the place of one of those tiny and otherwise useless knives. Being right-handed, I make the angle so that the slightly longer side is on the right; left-handed painters might choose to reverse this. The sharp corners that are left should be slightly rounded to stop them scratching. Cutting the end off with shears or wire cutters is not a good idea. It may be quicker, but it distorts the essential flat plane of the blade and causes all sorts of problems.

Working on canvas produces that slight 'give' in the surface which is one of its most delightful characteristics; but because the canvas, under pressure from whatever implement is being used, becomes slightly concave, it is vitally important that the blade of the knife can accommodate this curve. If the knife has a completely straight edge, the ends of the blade, especially the further one, will tend to take off the paint rather than put it on. I avoid this danger by giving my knife a very slightly curved line, filing it carefully to what I think is the best shape. Incidentally, this slightly convex curve on the blade is still perfectly all right when it comes to working on the more rigid surfaces of canvas boards.

All this, of course, presumes that the working surface is of fairly modest dimensions. Anything over 1m (3ft) would clearly need something bigger. I imagine that painting with a 5cm (2in) knife on an area approaching 1.75 sq m (20 sq ft) is not only going to take a great deal of effort but is also going to result in an over-laboured effect.

Occasionally, when working on large-scale pictures like this, I have used those scraping tools found in hardware stores which are more usually employed in taking paint off than, as

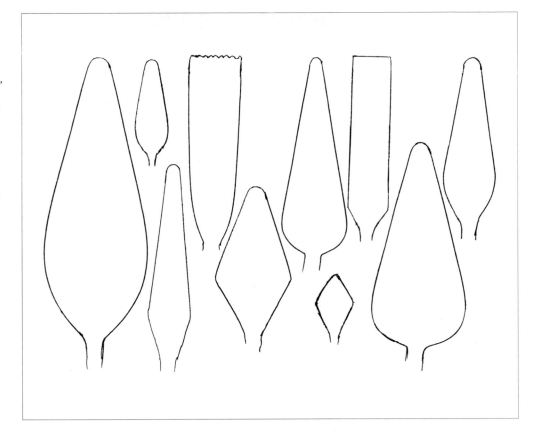

Some of the wide range of painting knives available. I would disregard all of them, with the possible exception of the large blade on the left, which might be useful, although only for the largest areas. The medium-sized triangular-shaped examples I would adjust to my requirements, as described on page 4. The rectangular models and the tiny ones are a waste of money!

in my case, applying it. You will have to adapt these too, of course, before you let them loose on canvas.

Advantages and disadvantages of using a knife

There are undoubtedly advantages in working with a knife, but the technique will not of itself transform an indifferent painter into a good one. Whether you apply your paint with a brush, knife, finger, or whatever, it has to be the right colour and tone and in the right place. The problem is to decide which these are. This, of course, depends upon your powers of observation and analytical skill. Unless you are prepared to look hard at your chosen subject to analyse the relationship of tones and to try to evaluate the subtle inter-reaction between one part and another, a knife will not be of much help to you. It may help improve your technique of painting by broadening your approach and simplifying the result, but unfortunately it can never be a substitute for study, and indeed there is the danger that it can lead to a superficial slickness which may give the impression of being good painting, but which will actually be more like those cheap and nasty mass-produced so-called 'original' paintings you see in the windows of high street chain stores.

One great advantage is that muddy colours become a thing of the past. There are no multicoloured brushes getting increasingly confused as different pigment is mixed with

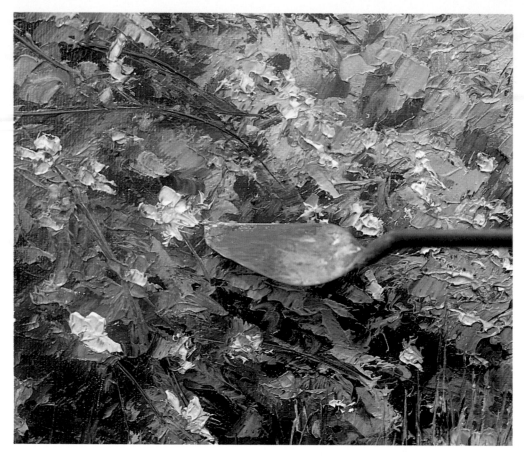

In this detail of roses (for the demonstration of wild roses, see pages 26–31), notice how I have filed off the tip of the knife at an oblique angle. I have also curved the bottom edge slightly to accommodate the slight give of the canvas.

earlier attempts, and you will avoid the confusion of trying to select the cleanest or most approximately coloured one from a fistful. There is no need to change from mixing the paint with one thing to applying it with another. If you wipe the blade on a rag, on the surrounding grass, or on your hat (my hat is a work of art itself), it is immediately clean and ready for the next move. When you are painting landscapes, and consequently very much at the mercy of changing light, speed of mixing and putting down the correct colour can be of the utmost importance. If you find you have chosen the wrong colour, then the same blade that put it on can just as quickly take it off again.

As far as using more paint is concerned, as long as this tendency is kept within bounds and under control it can be of positive advantage. Far too many painters, when learning, fight shy of impasto and apply their paint in such a thin and tentative way that the finished result always looks weak and unsatisfactory. Having said that, I do not believe that there is any value in thick paint for its own sake; but putting it on with a knife does not inevitably cause thick impasto. Depending upon how you work, the final picture can be as fine and delicate as if it had been put on in thin washes with small sables. This is one of the many versatile functions of a painting knife.

6

However, you might regard the fact that inevitably rather more paint gets used when painting with a knife as a disadvantage, especially as not all of it ends up on the canvas! Even what does get on to the canvas is sometimes more of a mess than a picture until you have gained enough experience to keep things under control. Furthermore, a knife that has been honed to razor sharpness by continual use, whilst of great value when it comes to slicing your lunchtime cheese or peeling your dessert orange, can with equal ease chop a chunk out of the thumb sticking through the palette. Also, while it has never happened to me yet, I imagine that it would not be difficult to cut through the canvas with a careless stroke. It is rather more likely, since your hand is nearer to the paint surface than it is when grasping the end of a brush, that you will find part of the picture attaching itself to a knuckle! With practice and a little care, though, this sort of drawback can be avoided, and then you will see the positive benefits of using a knife.

A painting produced with a knife should not necessarily look any different from one produced with the aid of a more conventional hog's-hair brush. In fact, I would argue that a painting that is clearly painted with a knife has been badly painted and has been defeated by its own technique. The marks that a blade makes naturally can all too easily become a tedious mannerism. Texture applied consciously and for its own sake is to be avoided, and the painter who slaps his paint on in flat slabs, hoping thereby to achieve an effect, is likely to have problems. The great thing about painting with a knife is that it inevitably encourages more freedom of expression and boldness of approach.

Materials and techniques

Most of my work is done outside the studio in the field, where problems of wind and changing light are more than compensated for by the very real pleasure of being part of the landscape I am engaged in painting. It is not always complete and unalloyed pleasure, though. For instance, I really suffer from wind! It is perhaps the worst enemy of an alfresco painter, possibly because other climatic conditions such as heavy rain or falling snow altogether rule out working out of doors. Nevertheless, the sound of the wind roaring through the trees is one of the most exciting and stimulating I know. If on a windy day, with the clouds racing across the sky and nearby trees howling in the gale, it is possible to find a comparatively sheltered spot where the easel will remain more or less stable, and the painting hand is able to obey the brain at the moment of impact, this can be a truly inspirational experience. It is far better, albeit more difficult, than working in the calm and languor induced by a warm and cloudless summer day. The wild atmosphere seems to imbue the senses with an urgency and excitement which, when transferred to the canvas, generally produces a far more interesting result.

Working outside in the countryside carries with it the attendant joys of looking at and trying to identify the surrounding wild flowers and the passing butterflies and birds. As I stand quietly at my easel I am sometimes approached quite closely by parties of fallow deer, or even by the smaller and more secretive Muntjac deer. The furtive rustle in the undergrowth at my feet followed by the squeaks of pygmy shrews, too, is a very common occurrence and another source of simple pleasure and amusement.

Working on canvas and board

Ideally I prefer to work on canvas, no doubt because of the give of the surface. I like a medium tooth or slight roughness (to help the adhesion of the paint to the canvas), but you can use a knife just as well on canvas with quite a coarse grain. The sometimes damp atmosphere of a characteristic English day can frequently slacken the tension of the canvas, so it helps to have something to hand to knock in the wedges as necessary. Canvases larger than, say, 75 x 50cm (30 x 20in) seem to have a great urge to take to the air, even when a heavy stone is

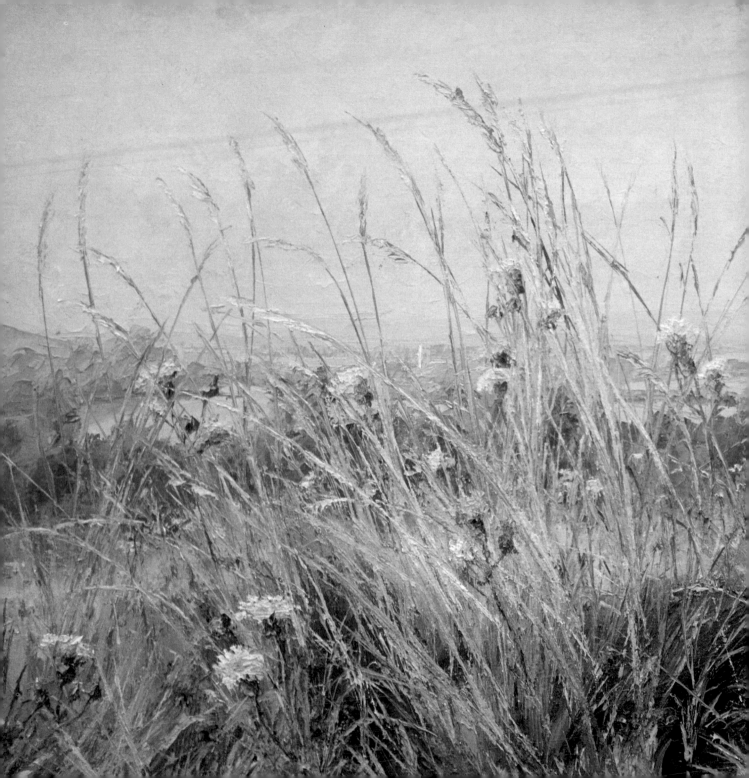

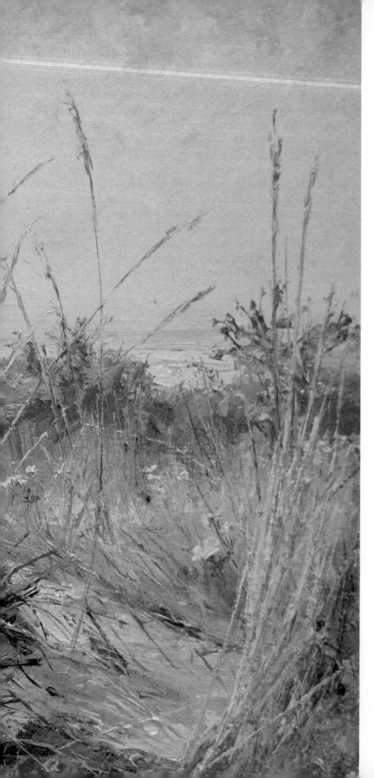

attached to the easel or its legs have been driven into the ground; therefore it is really better to use a smaller working surface. Also, the need to work quickly means that you should not undertake anything too ambitious in size. Indeed, if you are trying to achieve fleeting effects of light and shade, quite small boards, 25 x 20cm (10 x 8in) for example, are far better. For these smaller paintings I either buy the boards from my local supplier or else make them myself to my preferred shape and size. I boil up glue size according to the instructions and stick butter-muslin to the smooth side of hardboard which I have cut to the required size. (A special saucepan kept in the studio for this somewhat malodorous business is essential if domestic harmony is to be maintained. Likewise, I have found from bitter experience that dinner-time is not the best time to undertake this preparation.)

These boards, when dry, provide an excellent, slightly roughened painting surface. I have discovered, however, that if such panels get the least bit wet, the size begins to dissolve. So I always apply a coat of primer on top of the glue size if there is any likelihood of my working in damp or mist.

Applying the paint

I like to have at least a couple of similar knives to hand as I work, because even though it is very easy to keep the blade clean, it is still an advantage to be able to change from a dark to a light tone without the chore of having to clean it and then change it back again. I find that two are generally enough, otherwise you may experience the same confusion as may arise with a fistful of brushes.

My usual method of working is to apply the side of the knife to the canvas rather than the end, with a dragging action. I suppose this is rather like the way a plasterer works on a wall, although I am not consciously trying to produce a completely smooth surface. On the other hand, I have to say that

Sowthistle and grasses, near Ivinghoe Beacon

personally I do not enjoy texture for texture's sake. Quite often, indeed, when the paint is dry I shave off any chunks of pigment that are really standing up – yet another use of my knife! I do this because if an oblique light shines on the painting then bits of paint that are too thick will cast shadows and thereby give a false impression. I really do not recommend the technique of putting on the paint with the end of the knife in little blobs.

Whether I am painting with a brush or a knife, I avoid over-deliberate attention to the way the paint is put on. I do not consciously try to make an 'interesting' surface – my hand reacts instinctively to what I see.

Having spent all this time extolling the virtues of painting with a knife, I have to admit that my first approach to a picture is with a brush! When I have sorted out the composition with pencil or charcoal sketches, I transfer the broad outlines to the canvas with a brush and a very dilute mixture of pigment and turpentine. If, as often happens when painting outdoors, I am working against the clock in the sense that sunlight and shade are continually and rapidly changing, I will probably rub in with a broad brush as thinly and as quickly as I can what I think will be the most effective arrangement of tonal relationships. Only after this will I start using the knife. Then, analysing the subject with as much care as I can manage, I will *really* begin to paint, using rather more pigment and generally very little medium (linseed oil and turpentine).

A knife will produce cleaner colours than you can quickly get with brushes, and can also give a crisper effect when it is needed. But where, for example, in the distant background of the often misty English landscape, features tend to merge, you can also achieve this effect by dragging adjacent areas together whilst they are still wet, without the risk of making them muddy, or losing their subtlety.

I frequently put a considerable amount of close-up detail in the foreground of my pictures; for instance, tall dead grasses, or tall sowthistle, which is a common wild flower of the Chiltern Hills where I live and do a great deal of my work. The delicacy of these and of hogweed and cow parsley can be more easily produced with a knife than with a brush, no matter how fine. To do this, I collect the appropriate colour on the leading edge of the blade, making sure that there are no blobs, and then slide it down the canvas in the required shapes. This, of course, is where a long and completely straight-edged blade is less effective than one which is slightly curved and more under control.

Normally, however, it is best to use the knife nearly flat, smoothing the paint across the surface. This is why I prefer to have one edge, the right-hand or top one, slightly longer than the other. I prefer to work wet-into-wet, although of course this is not always possible. Admittedly, one of the greatest disadvantages of working with knives is that when there is a need to overpaint, the slightly crusty surface of the first layer is far from easy to work over. It is sometimes best to scrape off the underlying surface, repaint, and then add the next bits whilst it is still wet. Of course, some of the crustiness can be removed without too much difficulty, and I frequently do this to an otherwise finished piece of work so that any oblique light falling on it does not reflect too obtrusively. However, a dried and somewhat textured surface is not so good to work on as one which accepts the paint more sympathetically.

Watery Lane: demonstration

Original size: 60 x 45cm (24 x 18in)

It is a day in early spring with lots of wind and racing clouds with all the promise of good things to come. The most important thing is to try and capture the freshness, as there is not going to be a lot of time to consider finer details. It is very much an impressionist sketch, in fact, and speed is of the essence.

Stage 1

The main lines of the composition are the diagonal of the road opposing the diagonal of the cloud shadow. I now block them in, rubbing in quickly with thin paint and a fair-sized brush. The position of the trees is quickly suggested with a blue-grey tone composed of indigo and Vandyke brown plus titanium white.

Stage 2

Next, I paint the main tonal contrasts in the sky where dark clouds are going to show up the orange willows, and the lighter part which will balance the sunlight on the road. It is called Watery Lane because of a spring at the side of it which seems to keep the surface at this point almost always wet, and it therefore reflects the general tone of the sky. So the sky and the road are dealt with together as much as possible.

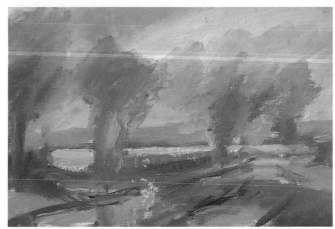

Stage 1

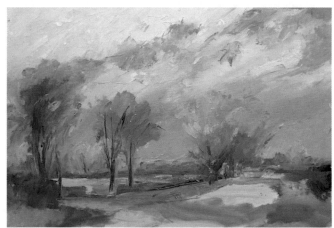

Stage 2

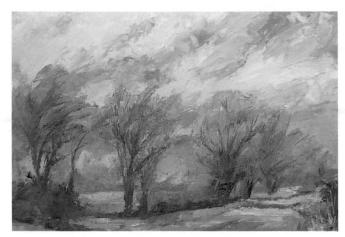

Stage 3

The dark tones are made up mostly of indigo whilst the light edges of clouds contain a large proportion of Mars yellow. Mars yellow is somewhat similar to a dark yellow ochre but with a delicious warm pinky effect that I find marvellous for clouds. The green for the verges I usually mix from indigo and chrome yellow, plus viridian and pale cadmium yellow where it needs lightening or sharpening.

Stage 4 – the finished painting

I work on all parts of the painting as much as possible at the same time, inter-relating the colours everywhere and making small adjustments if necessary.

Next, I rough in the sunlit trees in the middle distance and the somewhat denser foliage of the willows at the corner. The nearer trees, hawthorns I think, are not so far in leaf and their main shapes and branches are now painted, together with those of the willows.

Now I pay more attention to the road itself. Here, as in the foliage of the trees, I use the flat of the knife, but when it comes to the detail of the verge in the right-hand corner, I use the edge to suggest the grasses catching the sun.

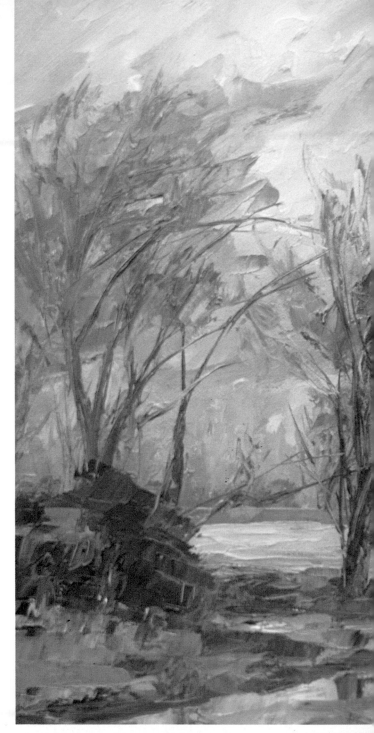

Stage 4 – the finished painting

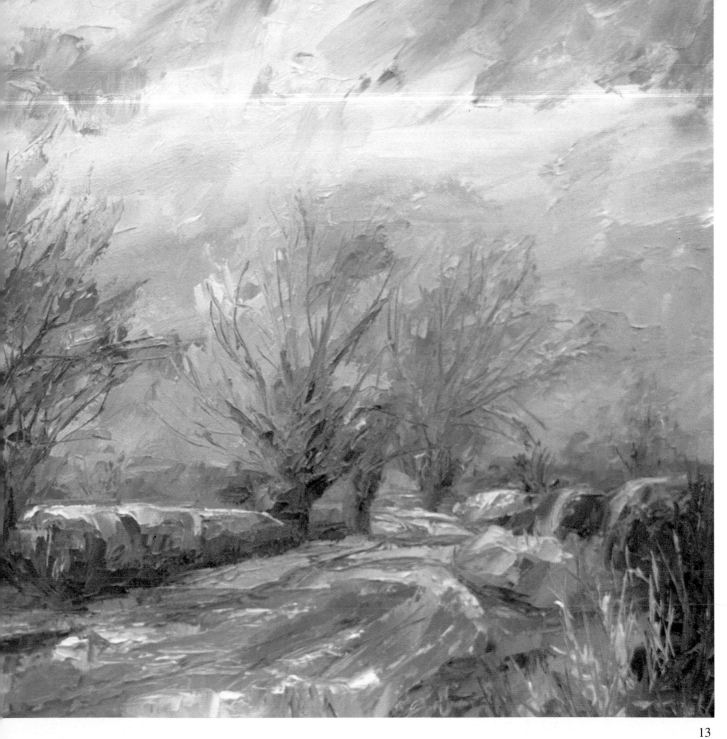

13

Poppies: demonstration

Original size: 90 x 60cm (36 x 24in)

One of my favourite subjects is looking from the escarpment of the Chilterns, where I live, over the wide expanse of the Vale of Aylesbury below. This panoramic view is always full of delight, but I find it particularly exciting to paint when the wind is blowing clouds across the sky, creating rich and varied shadows on the landscape. Capturing it on canvas, however, is fraught with difficulty. For a start, the lights and darks are continually changing places, so that what is there at one moment is completely different at a second glance. Furthermore, cloud shadows are caused by my greatest problem – wind. So these difficulties are exacerbated by having to work at an unstable easel with a hand intermittently unsteadied by sudden gusts. Therefore, I study the landscape carefully for a good while before beginning to paint, in an attempt to decide where best to establish dark and light tones. Once I have made these decisions, I try to stick to them, no matter what variations continue to occur.

For this particular painting I was lucky enough to come across a field which, no doubt much to the farmer's displeasure, was full of poppies and wild marguerites. These, together with the more commonly found tall grasses and oats, were clearly designed to give me an ideal foreground. I was working on a comparatively large scale – 90 x 60cm (36 x 24in) – which is about the largest size that can be comfortably managed outside. Too large, perhaps: the canvas tended to behave as though it were attached to the mast of a boat rather than to a light easel. I found some shelter, however, and by digging the legs of the easel into the ground and tying to it one of the large flints which abound hereabouts, I managed to get a relatively stable working surface.

Stage 1

My first task is to establish the sky. Best of all I like a sky which is clearly three-dimensional, with different layers of clouds, so that the space which is indicated on the ground is also visible above. A landscape which recedes happily enough until it comes up against a flat background like the back of a stage set is not very convincing.

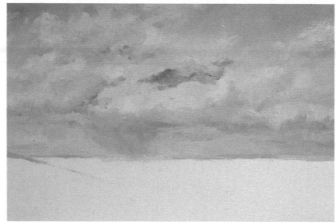

Stage 1

As I am proposing to paint grasses and oats against the sky, it is vital that I get the sky as I want it before that stage is reached. I spend quite some time on this, because once the grasses are painted it will be almost impossible to change it. The main colours I use here are titanium white, cobalt blue, and Mars yellow. There are additional touches of alizarin crimson, and also indigo, a rich dark blue which is very useful in shadows.

Stage 2

It is always difficult to relate the other parts of a painting to bare white canvas, so I rub in fairly loosely, with thin paint and a broad brush, the basic underlying tone and approximate colour of the foreground. True accuracy here is not important, since I shall be painting over it in due course. I am content so long as it bears some resemblance to my intentions, and is above all no longer that glaring white. But it makes me realize that the sky is too strong, so I have to soften its effect. Then I begin to pay attention to the landscape in the distance. The tone values of this receding plain are of vital importance if it

is to look as though it goes on for several miles, which of course is the illusion that I want to create. The further away the land, the nearer the tone is to the sky at the horizon. Sometimes, indeed, there is no clear definition between land and sky. Cloud shadows need similar concentration on tone value. I give the nearer ones a beautiful rich deep purple colour which dramatically picks out the little church of Edlesborough in the middle distance. I make this colour with indigo and crimson alizarin plus a little black. Normally I discourage the use of black – when I have found it in a student's box I have been known to throw it away! My reason for this is that it is too easy to darken a colour with the addition of black. It certainly darkens it but it also, in most cases, kills it. Black scarcely exists in nature. It is far better, although admittedly more difficult, to try to analyse dark colours more carefully and make them with tones other than the deadening black. There are, of course, times when black can be used without ill effect, but these occasions are rare, and careful consideration is needed. If there is no black in the box, then any temptation to use it for want of anything better is avoided.

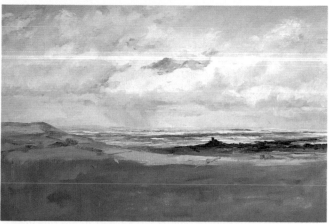

Stage 2

Stage 2 – detail

Edlesborough Church, sitting as it does on a curious hillock, is of great importance in the composition – if it were not there I should have had to invent it, or something like it! Sometimes it catches the sun and gleams brightly against a dark background; sometimes it appears dark and imposing against the light. This is where you must make a choice and keep to it: I chose the latter.

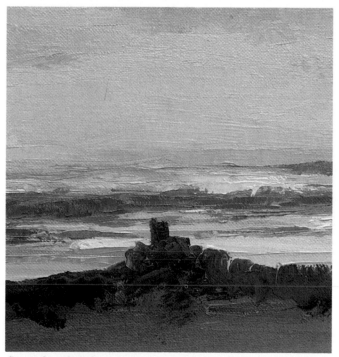

Stage 2 – detail

Stage 3

A canvas this size is going to take at least two days' work to complete, so I have to plan ahead. The most serious drawback to painting with a knife is that it is difficult to paint over a surface of dry and crusty paint, and it nearly always looks clumsy, too. I want to paint grasses into the sky, which helps to give interest to the foreground, and, perhaps more importantly, also joins the ground to the sky so that there are not two distinct and separate parts to the painting. It is best to do this whilst the sky is still wet, so although there is really no ground as yet for the grasses to grow out of, I nevertheless, at this stage, begin to paint their tops and seed heads.

There are hundreds of different species of grasses. Whilst I am not going to paint many of them, at least I try to distinguish with considerable care the characteristic features of one or two kinds. I use the side of my knife-blade with paint only on the very edge, so that no unwanted blobs end up where I want only the finest of lines. With this method, wet-into-wet, I get the effect of thin stalks far more easily than with the finest of brushes.

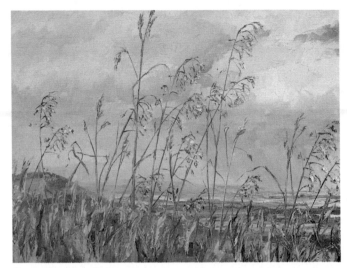

Stage 3 – detail A

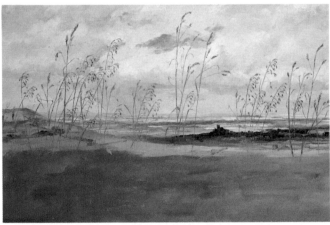

Stage 3

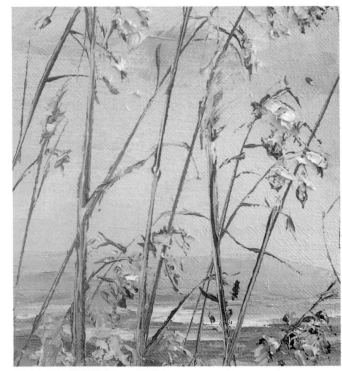

Stage 3 – detail B

Stage 3 – detail A

Should any little accidental blobs occur, I can, without too much difficulty, transform them into other pieces of grass! The seed heads, too, are put on with the shortened end of the knife whilst the underlying area is still wet. Once the sky has been allowed to dry, the process becomes, and looks, far more difficult.

Stage 3 – detail B

I want to indicate that even thin stalks of grass have a discernible form, and so, having painted the main stalks, which obviously look dark against the sky (in a mixture of Vandyke brown and Mars yellow), I then paint a light edge with white plus yellow ochre, again using the edge of the knife to carry the smallest amount of paint necessary.

All this takes most of the first day. If tomorrow does not turn out to be as good as today, then at least I shall not have to worry about the problem of trying to work on dry paint.

Stage 4

When I come back to the painting, the top part is dry. It is also, fortunately, more or less complete, and I can concentrate entirely on the lower part. I am aware, of course, that ideally the whole of a picture should be worked on all the time, each part relating to all the others, until with the final stroke, rather like the last piece in a jigsaw puzzle, it is complete. This is, however, not always so easy, and the need to work wet-into-wet is paramount.

Over the underpainting, I anchor the tall grasses to the ground, so that they are not just floating about in the air, by painting, in pale yellow ochre, the suggestion of a great deal more grass. This is not so tall or so fine, but nevertheless it breaks up into the background. The position of the red poppies is very important. I need to place them carefully: a straight row of them would be ridiculous, and anything that is likely to resemble a team photograph of redheads is clearly to be avoided.

Painting lighter or darker shades of a colour can be difficult, and is particularly so in the case of red. Dark reds tend towards brown or purple whilst the paler versions often just look pink. Poppies themselves are not all the same colour, which might in some way alleviate the problem; great care is required to paint some in the shade and others catching the light. I have to choose the right red to begin with, and, unfortunately, some pigments, like vermilion, are fiendishly expensive. However, by adding alizarin crimson and burnt umber with great care, I manage to produce some shaded blooms, whilst lemon yellow and the tiniest proportion of white help to suggest those in the sun.

Stage 5

Next, I introduce the wild marguerites. These cover some of the green underpainting, fill spaces between poppies, and, above all, lighten the general effect.

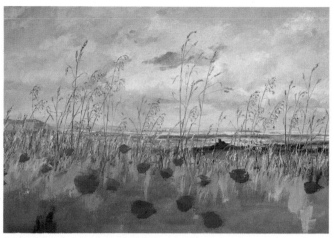

Stage 4

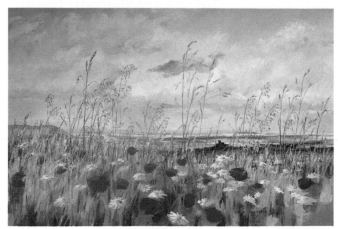

Stage 5

Stage 6 – the finished painting

Finally, blades of grasses are brought down to the ground and more detail is added to some of the flowers. I add a couple of poppies against the sky to join up the two halves of the painting – and the painting is finished.

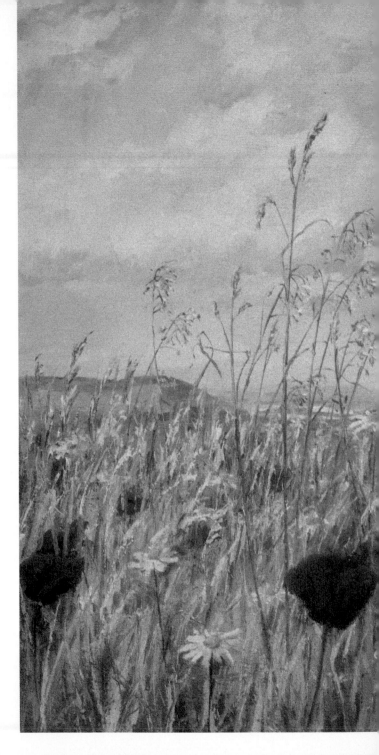

Stage 6 – the finished painting

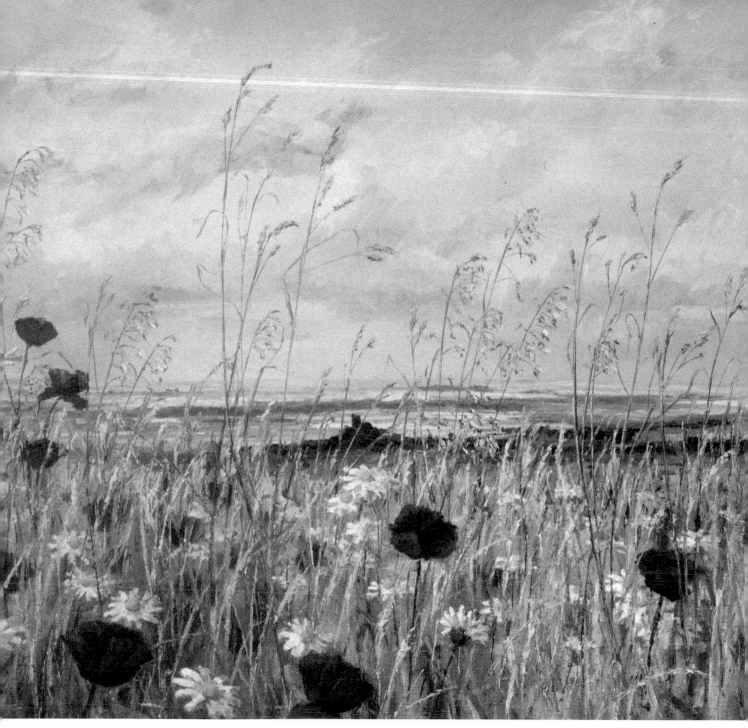

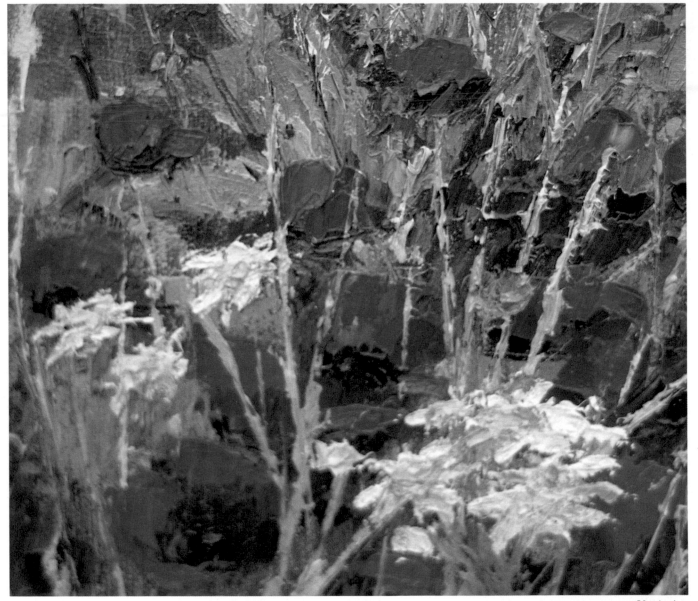

Variation

Variation

Poppies also fill the foreground of the painting of Edlesborough Church shown on pages 2–3. As you can see from this detail, the techniques used to paint the poppies and the marguerites are the same as those described on pages 16–18. Again, I have added the tall grasses with the edge of my knife.

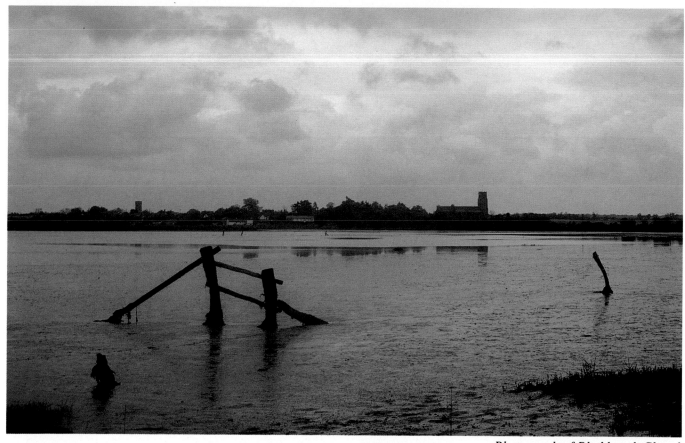

Photograph of Blythburgh Church

Blythburgh Church: demonstration

Original size: 75 x 50cm (30 x 20in)

When I decided to paint this view across the estuary, using the beautiful church as a focal point, the weather was very unsettled, with quite a strong wind and intermittent squalls of rain. I had to decide what sort of sky seemed best suited to the scene, and, since I knew that the painting would occupy me well into a second day, whether the sky would be much the same on the next day. The church, called the 'cathedral of the marshes', is easily the most dominant feature in what might otherwise be considered a relatively dull landscape, the greater part of it being made up of the sky and its reflection in the water. So a painting of it made on a hot summer day could well be less than riveting. Rain clouds being chased across a higher layer of cirrus cloud and patches of pale blue sky would make a more interesting composition. The other factor I needed to bear in mind is that this is a tidal estuary with water alternately covering and exposing the mud flats. Should the tide be in or out? I decided to paint it with most of the mud flats under the water.

Stage 1

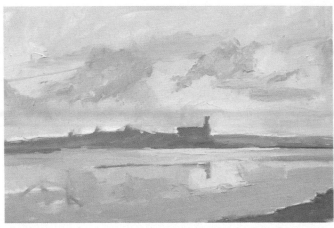

Stage 2

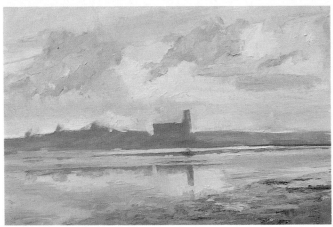

Stage 3

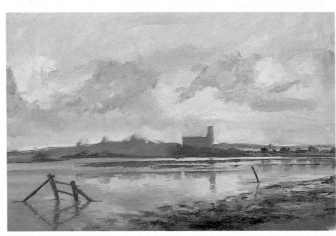

Stage 4

Stage 1

Firstly, I rough in the composition with paint thinned with turpentine and applied with a large brush. The two main components that have to be established are the line of the water and the position of the church tower; both, incidentally, conforming more or less to the golden section. Once they are determined I quickly cover the canvas, using a No. 8 brush to suggest the overall tone scheme. The shape of the muddy foreground is indicated and, whilst I do not put it in clearly at this stage, I am nevertheless aware that the bottom left-hand corner will contain, as a balance, the section of broken fence or jetty or whatever it is.

Stage 2

Having prepared the ground in this way, I now bring out my knife and, using thicker paint, loosely suggest the shapes and positions of the main cloud formation. I know that I shall probably change them a bit, but this is the essential idea of the sky. The reflection in the water, too, is considered, so that the dark of the tower is seen against a patch of light.

Stage 3

Now I establish more firmly the part of the mud and dry land that I have decided to incorporate into the composition, in order to keep in mind the overall tone and colour arrangement. However, as this part of the landscape is one of the more stable elements, apart from the inevitable transitory changes of light upon it, I deliberately leave it until later and pay more attention to the water, with its reflections of the church and the strip of land upon which it stands. It does not matter if the faint outline of the jetty gets painted out whilst I am working on getting the water right, as I can easily re-establish it at the next stage.

Stage 4

At this stage I concentrate more on the shapes of the reflected clouds in the water, and on making the water look wet! Indeed, I refine the reflections to a large extent even before I properly define the shapes that cause them.

Stage 4 – detail

Next, I pay attention to the various bits of dilapidated wood-work. These are an extremely important part of the composition and I chose this particular point of view in the first place because of them. Just imagine how much less interesting the composition would be without this curious structure in the left foreground.

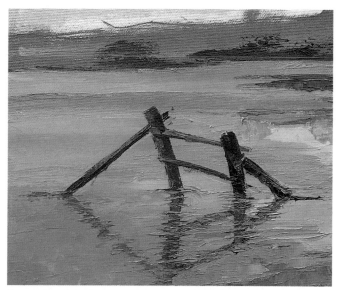

Stage 4 – detail

Stage 5 – the finished painting

I lay in the sky with more definition, with the water very much in mind so that a light piece of sky does not appear over a dark reflection. The main colours used for both the water and the sky are a base of titanium white with indigo and Vandyke brown mixed together for the darker areas and with Mars yellow for the lighter parts of the clouds. Painting the reflection first may seem a bit back to front, but it is essential to get the water sorted out before the tide ebbs; and so long as the kind of weather remains much the same, the final positioning of clouds is easy enough to reproduce without referring directly to what is happening at any one moment. After all, the sky is never still for long enough to let you paint exactly what is there anyway. What you *can* reproduce is the character of the day.

Finally, I finish off the church and the land, and with a bit of tidying up the painting is complete.

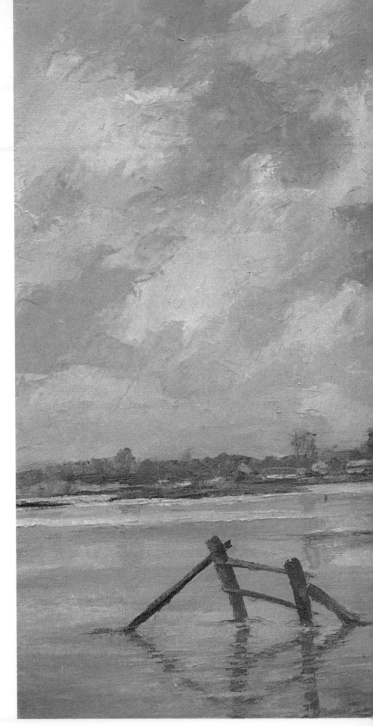

Stage 5 – the finished painting

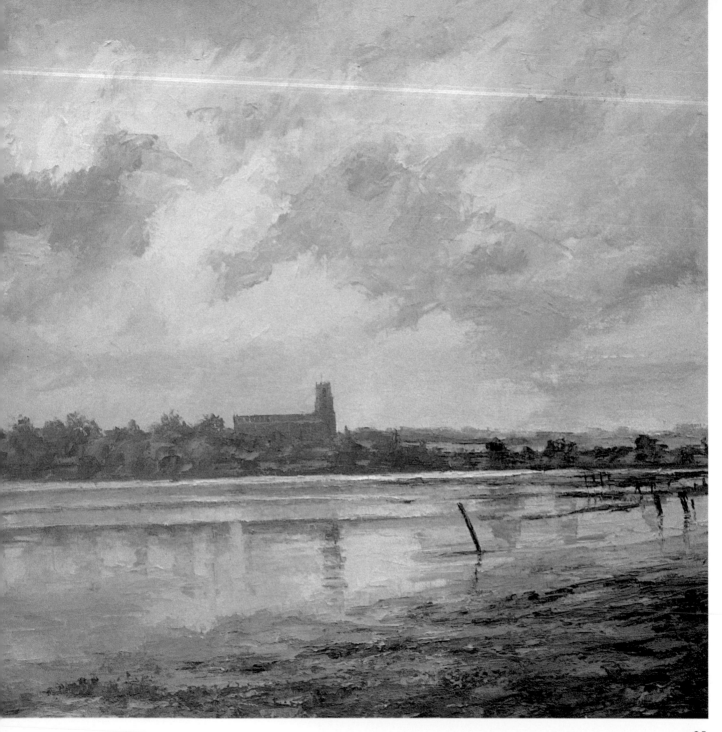

Wild roses: demonstration

Original size: 50 x 40cm (20 x 16in)

In a disused quarry near my home a self-sown nature reserve has established itself, with lots of different species of wild flowers and butterflies. The wild roses there, in particular, are prolific, and make an extremely attractive sight. A rough path between the bushes helps to provide the sort of composition I favour, leading into the supposed depth of the picture.

Stage 1

With thin paint and a large brush, I quickly cover the white of the canvas and block in the main masses where I want the roses to be on either side of the track.

Stage 2

Unless I need to do something urgently, such as fixing some transitory effect in the foreground, I usually work from the

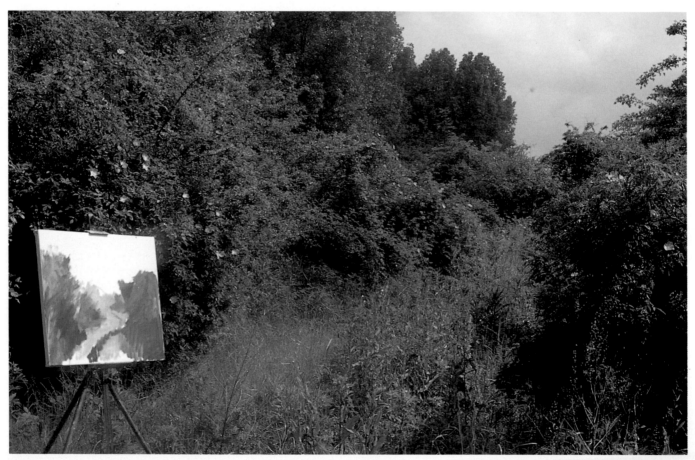

Photograph of the painting in situ

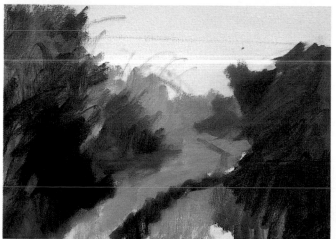

Stage 1

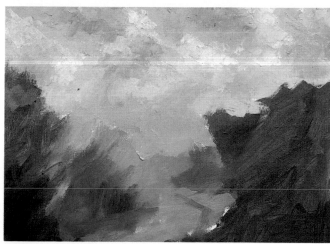

Stage 2

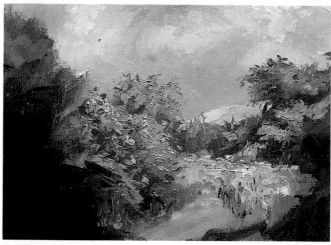

Stage 3

Stage 4

distance towards the nearest point. This is very important where trees are to be painted against the sky, since it is a laborious business to paint sky into the edges of the branches – and it looks it, too. So my next task is to paint clouds and sky, smoothing on the pigment quite loosely with the flat of the knife.

Stages 3 and 4

Then, gradually working towards the foreground, I try to assess the correct colour and tone of the further grasses and cow parsley, not forgetting a glimpse of Ivinghoe Beacon in the distance.

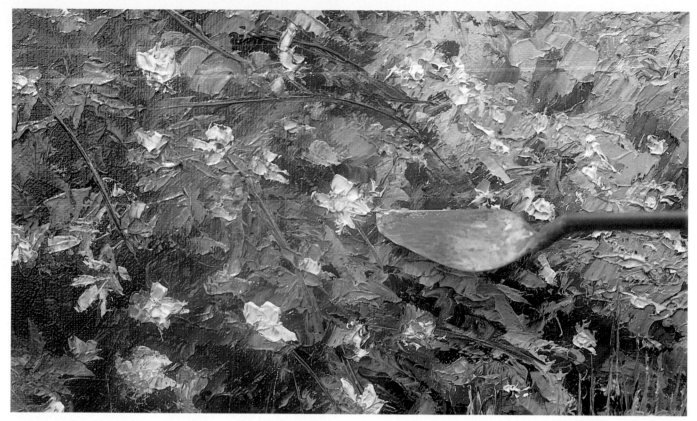

Stage 4 – detail B

Stage 4 – details A and B

When painting the roses, I apply the pink colour quite thickly with the end of the knife, and those branches which I choose to include are put in with the edge of the knife. Of course, not all the roses are equally lit up by the sun, just as quite a lot of the bushes are also in shadow; so there is a considerable degree of variation in the colour of both the roses and the foliage. As with a brush, it is easier to work from dark to light, but the knife definitely lends more crispness to the result, so that the blooms stand out bright and clear on the bush.

Stage 5

Towards the end of the day, as the light changes, I decide that it is time to stop and look at it more objectively – and with a less weary eye. Too often it is impossible to assess properly what one has been working on closely for the previous hour or

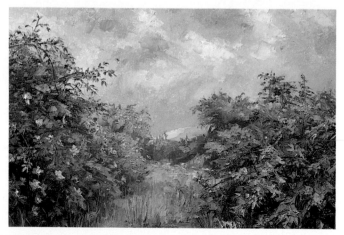

Stage 5

so. I am sure we have all had the experience of returning to a painting and finding that it is not quite so good as we had supposed when we left it! So I shall look at it in the studio in the clear light of a new day, when my critical faculties are not so dulled.

Next day, with my batteries recharged, I realize not only that the two main bushes are too evenly disposed on either side, but also that the whole effect no longer conveys the feeling of sunlight on roses.

It is frequently the case that on site too much attention is paid to the actual conditions of the landscape, which can then distract from the effect I want to convey. In the studio, away from these distractions, it is easier to appreciate the work on its own terms without reference to the scene in question.

Stage 6 – the finished painting

In the final stage, and working entirely in the studio, I bring the right-hand bush down to the bottom edge of the canvas. This, I hope, achieves a better composition by suggesting that one bush is nearer and smaller than the other. A greater emphasis on the path going into the middle distance and round the corner helps to enhance the illusion of three dimensions.

But, above all, a lot of work is done to lighten the overall appearance, both in the sky and in the foliage, so that in the end I hope that the painting more effectively shows a bright sunny day in early summer.

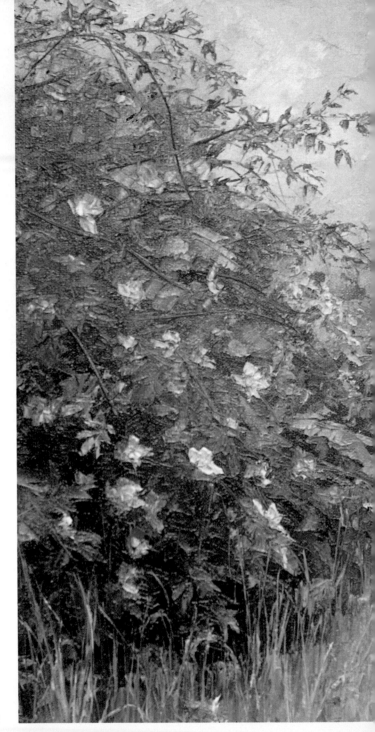

Stage 6 – the finished painting

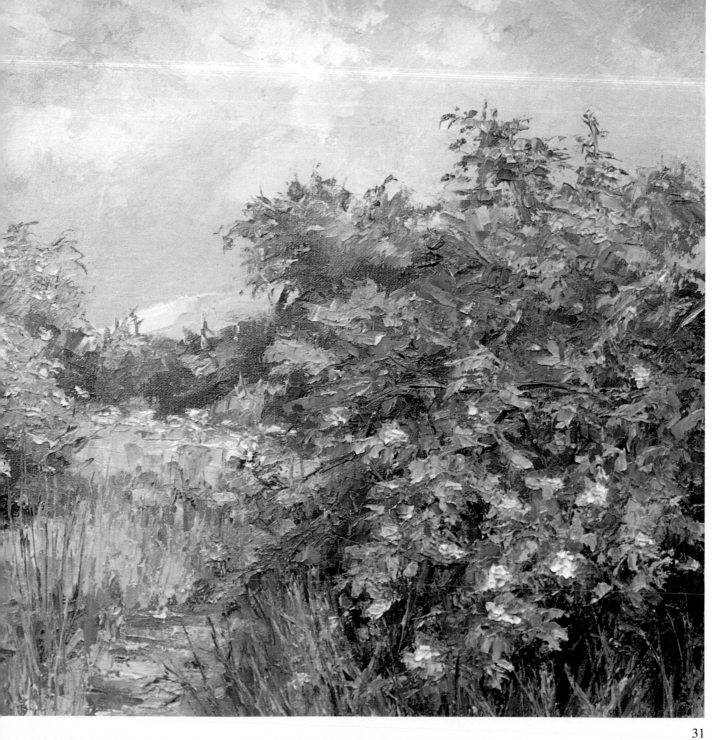

First published in Great Britain 1993
Search Press Limited,
Wellwood, North Farm Road,
Tunbridge Wells, Kent TN2 3DR

Text, photographs, drawings, and paintings by Brian Bennett
Text, illustrations, arrangement, and typography
copyright ©1993 Search Press Limited

ISBN 0 85532 717 0

Distributors to the art trade:

UK

Winsor & Newton,
Whitefriars Avenue, Wealdstone,
Harrow, Middlesex HA3 5RH

USA

ColArt Americas Inc.,
11 Constitution Avenue,
P.O. Box 1396, Piscataway, NJ 08855-1396

Arthur Schwartz & Co.,
234 Meads Mountain Road, Woodstock, NY 12498

Canada

Anthes Universal Limited,
341 Heart Lake Road South, Brampton, Ontario L6W 3K8

Australia

Max A. Harrell,
P.O. Box 92, Burnley, Victoria 3121

Jasco Pty Limited,
937-941 Victoria Road, West Ryde, N.S.W. 2114

New Zealand

Caldwell Wholesale Limited,
Wellington and Auckland

South Africa

Ashley & Radmore (Pty) Limited,
P.O. Box 2794, Johannesburg 2000

Trade Winds Press (Pty) Limited,
P.O. Box 20194, Durban North 4016

Printed in Spain by A. G. Elkar, S. Coop, 48012 Bilbao